DIGITAL QUICK GUIDE™

THE PARENT'S
GUIDE TO **PHOTOGRAPHING**
CHILDREN AND FAMILIES

Kathleen Hawkins

AMHERST MEDIA, INC. ■ BUFFALO, NY

This book is dedicated to Michelle and to all those people who brought this precious angel into our lives. Michelle, we are blessed to have you join our family and look forward to photographing your beautiful little face time and time again! You have brought us more joy than we could ever have imagined.

Published by:
Amherst Media, Inc.
P.O. Box 586
Buffalo, N.Y. 14226
Fax: 716-874-4508
www.AmherstMedia.com

Publisher: Craig Alesse
Senior Editor/Production Manager: Michelle Perkins
Assistant Editor: Barbara A. Lynch-Johnt

ISBN: 1-58428-161-8
Library of Congress
Card Catalog Number: 2004113077

Printed in Korea.
10 9 8 7 6 5 4 3 2 1

TABLE OF CONTENTS

INTRODUCTION

Your family is precious, and because children grow so fast, it is important to capture each moment and make sure the memories last. As busy as you may be, make picture-taking a priority. Capturing great images will help you to create family heirlooms and to share and preserve your family's unique story.

Whether you are new to photography or just new to digital cameras, this guide will walk you through all of the basics. You'll learn how to select and use a digital camera, then you'll move on to discover simple techniques for making your child or family photograph look its very best. You'll learn how to select the best locations for family portraiture, how to prepare your images for e-mail and websites, and how to print them at home or through a professional lab. Finally, this book will even help you to decide when and how to hire the professional family photographer who's right for you!

Now, let's investigate the many advantages that shooting digitally offers.

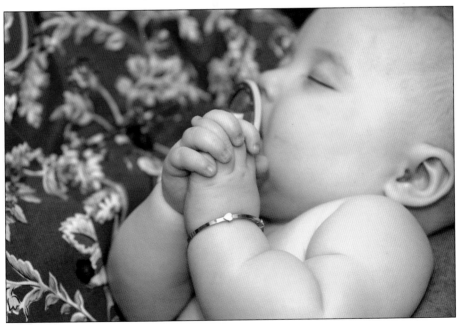

Children grow so fast. It is important to capture each moment to make sure those memories last!

1. ADVANTAGES TO DIGITAL CAPTURE

Like most people, you probably rely on technological "gizmos" every day. You use a Palm Pilot to keep track of your busy schedule. You jump online to check your e-mail or download a photo from a friend. Everyone in your family may have cell phone. So, is it time to purchase a digital camera?

The answer is, yes! Digital cameras can make taking photos easier and more fun! These little marvels allow you to travel lighter, be more creative, and organize your images, all while saving money.

◼ INSTANT GRATIFICATION

One of the biggest benefits of digital capture is the ability to view your images immediately after pushing the shutter button. You can instantly determine whether the shot should be retaken or is worth keeping. Because you can

retake your images when necessary, the technical and artistic aspects of your pictures will improve.

Digital cameras are lighter and easier to travel with than film cameras. You can take your camera every-where you go! Image by Angi Aveyard.

 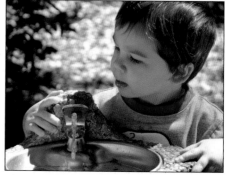

By looking at his camera's LCD monitor, Erik Wyand noticed that his flash went off and caused the image to be overexposed (left). Fortunately, he was able to modify his camera's settings and continued to capture his little tyke in action (right).

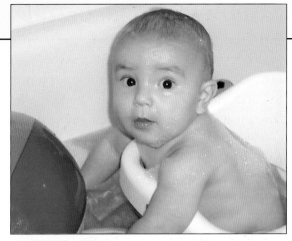

When you use an LCD monitor, there's no need to wait for your film to be developed to ensure that you got a good shot. Photo by Bonnie Califano.

With a digital camera, you can capture as many images as you want, as often as you want to! Photo by Erik Wyand.

■ DIGITAL IMAGE EDITING

With an image-editing program, you can resize your images, add fun effects, enhance contrast, and remove unwanted distractions from an image.

■ LOWER EXPENSES

While the cost of a new camera might deter some parents, shooting digitally is actually less expensive than shooting film. The average family spends $30 a month in film and processing costs. Switching to digital, the typical family reduces their monthly expenses to $5 a month. With savings like that, the equipment will pay for itself within the first few years!

2. EQUIPMENT: ANALYZING YOUR NEEDS

Before you head to your local electronics store to pick up a new camera, first analyze your family's basic photography needs.

1. Are you searching for a camera that will give you good images both indoors and outdoors?
2. Do you need a camera that will easily fit in a diaper bag or purse?
3. Are you primarily looking to photograph your children, or do you also hope to create great scenic shots while on your family vacation?
4. Do you want to e-mail images to friends and family members or post them on a family website?
5. Do you want to make prints to display in your home or to give as gifts?

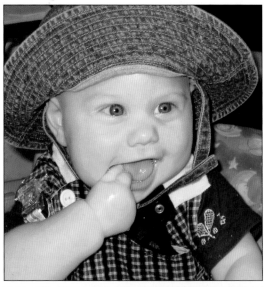

A digital camera that gives you the ability to take quality digital images both indoors and outdoors may be beneficial for your family. Photos by Elizabeth Cook.

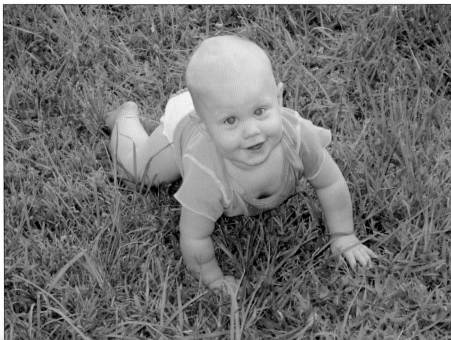

Will you be taking mainly portraits or do you also hope to shoot some beautiful landscape images?

Will you be happy with images that are 5x7 inches or smaller, or do you prefer 8x10-inch or larger prints?

Once you've determined what your needs are, you'll need to select a camera format and learn about the camera's different features and functions. You'll also need to learn about the memory devices that are available and the best batteries for the job!

How do you plan to use your images? Will you want to e-mail them? Make prints to share? Image by Laura Green.

3. EQUIPMENT: CAMERA FORMATS

Today's cameras come in a variety of sizes with differing features and varying prices—but each one will allow you to capture and share your memories quickly. Because new models are constantly being introduced, it is beyond the scope of this book to detail specific models or their features. There are, however, two basic digital-camera formats on the market: point & shoot and single-lens reflex.

■ POINT & SHOOT

The more common of the two consumer-friendly camera formats is a point & shoot. The point & shoot camera is typically easier to use because the flash and the lens are built-in (noninterchangeable), and all you have to do is point and shoot (hence the name)! These cameras are typically small enough to fit in a diaper bag, purse, or even your pocket, which makes them the perfect choice for taking pictures at home or while on family outings.

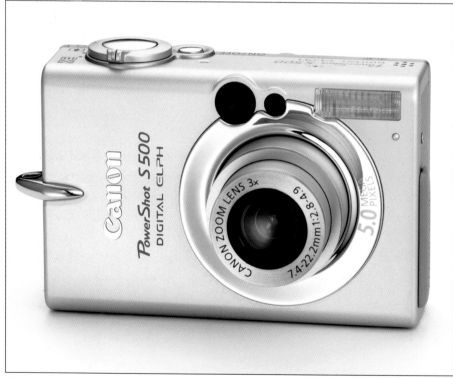

This Canon point & shoot camera is compact and lightweight—perfect for any parent who's on the go! Photo courtesy of Canon, Inc.

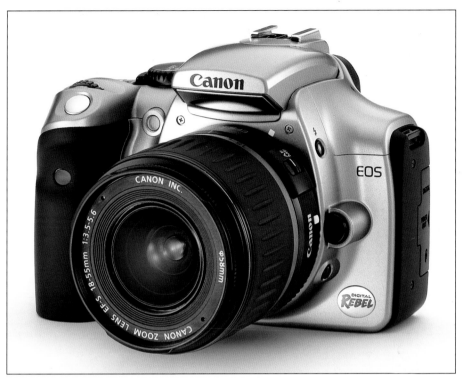

The Canon Digital Rebel is one of the most complete consumer-grade SLR systems on the market. Photo courtesy of Canon, Inc.

■ SINGLE-LENS REFLEX (SLR)

A single-lens reflex camera allows photographers more options and is available at a higher price. SLR cameras usually offer more creative controls, because most of them have the ability to accept a variety of lenses. Additionally, you can manually select shutter speeds and apertures. (These will be discussed in lesson 14.)

Whether you are shopping for a point & shoot camera or an SLR, consider the guidelines in lesson 10 to make the best possible selection.

4. EQUIPMENT: IMAGE SENSORS

■ THE ROLE OF IMAGE SENSORS

Before the digital camera was invented, all images were captured on light-sensitive material called film. Digital cameras—no matter the size, cost, or other characteristics—capture images on an image sensor.

■ PIXELS

The image sensor contains numerous light receptors, each of which captures one pixel (or "picture element") of the final image. Each pixel has its own color and shade, and when all the pixels are combined, they form an image.

■ RESOLUTION

Resolution is the measurement of the number pixels the image contains. This may be expressed in a "width x height" format. In other words, if your camera produces images with a resolution of 2048x1536 pixels, your photo will be comprised of 2048 pixels along the width and 1536 pixels along the height. The resolution of an image may also be expressed in terms of the dots (pixels) per inch (dpi). In general, the higher the resolution (the more pixels or dots), the better the print quality.

■ IMAGE-SENSOR RATINGS

By multiplying the pixel width by the pixel height, manufacturers compute an image-sensor rating. For example, a camera that captures a 2048x1536-pixel image has a 3.2MP sensor (2048x1536=3,145,728 pixels [this number is rounded up]).

Cameras with larger image sensors capture far more picture information than do cameras with smaller image sensors. If you choose a camera with a

SIZE MATTERS

While it's great to have lots of pixels to work with, cameras with smaller image sensors have the advantage of being smaller and more lightweight (many weigh just a few ounces). If you are juggling multiple children—or if you intend to create only small prints or to produce images to use in e-mails or on a family website—it may be advantageous to select a smaller camera. Your digital camera should be one that you are comfortable carrying and using.

With digital cameras, your images are captured on an image sensor instead of film.

3.2MP (or higher) sensor, you'll be able to print a good-quality 8x10-inch image.

While the topic will be covered in greater detail in lesson 5, for now, it is important to note that once the digital picture information is captured on the image sensor, it is stored on a memory card (SmartMedia, CompactFlash, and others).

5. EQUIPMENT: MEMORY DEVICES

The pixels captured by a digital camera's image sensor are processed and stored on a memory card. (Though Sony cameras store image data on memory sticks or mini CDs.)

With digital, your images are stored on a memory card rather than on film.

■ CARD FORMATS

Memory cards come in a variety of formats, including SmartMedia, CompactFlash, xD-Picture, SecureDigital (SD), and MultiMedia-Cards (MMC). CompactFlash cards are currently the most popular option, though xD cards provide the most storage space (the latter can be used with a PCMCIA or Compact-Flash adapter in any camera that utilizes CompactFlash cards). Some manufacturers also produce cameras that will accept both SmartMedia and CompactFlash cards (each of which is housed in a different slot).

■ SIZES

While the format of the card you will use is dictated by the camera you choose, you can purchase these cards with varying amounts of storage capacity. Running out of memory is no different than running out of film, so consider buying a high-capacity card or a few cards so you don't have to rush to download your images before you can continue to shoot!

MEMORY CARD CAPACITY
(APPROXIMATE NUMBER OF IMAGES PER CARD)

	2MP	3MP	4MP	5MP	6MP
16MB card	17	13	8	6	5
32MB card	35	26	16	12	10
64MB card	71	53	32	25	20
128MB card	152	106	64	51	40
1G card	1137	853	512	409	320

The camera's file size (MP) and the memory card's capacity (MB) determine the number of images that cane be stored on any given card.

The amount of data that a given card can accommodate is rated in megabytes (MB). It's a good idea to start with a card that offers 256 megabytes (MB) of storage (you can buy a card that holds more images later on if you shoot more often than you anticipated or cannot frequently download your images). With a card this size, you can expect to capture 80–304 images (double that captured on a 128MB card).

To estimate the number of photos that you can capture on a given card with your specific camera, determine the camera's sensor size, find your memory card capacity, then consult the chart on the facing page.

■ CARD READERS

Card readers are handy devices that attach to your laptop or desktop computer via a USB or FireWire cable (the latter yields faster results). To download your images to your computer, you need only remove the memory card from your camera and insert it into a compatible card reader. Some computer systems are equipped with built-in card readers, as are some printers.

When on vacation, consider traveling with a portable hard drive or laptop or taking the time to download your images onto a CD to safeguard your images.

6. EQUIPMENT: FLASH

BUILT-IN FLASH

All but the least expensive digital cameras on the market offer a built-in flash that you can use to ensure that your subjects are well lit and properly exposed. Many cameras allow you to select settings that cause the flash to fire when the camera thinks it's needed or to manually activate it on an as-needed basis.

EXTERNAL FLASH

If the camera you're interested in has a hotshoe at the top, then you can mount an external flash on your camera. This option is more versatile than a built-in flash. For one, because the flash is mounted farther from the lens (in comparison to a built-in flash), you're less likely to encounter red-eye in your

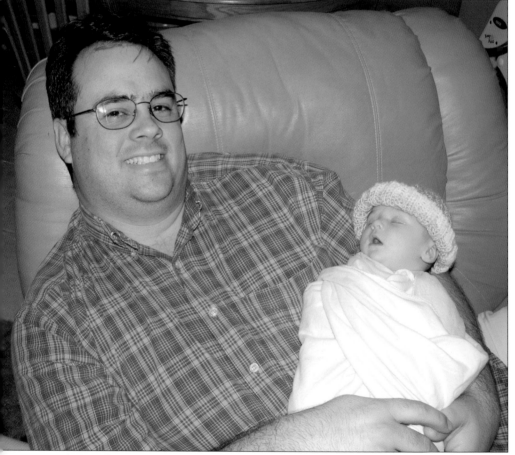

Flash is effective for lighting indoor portraits. Photo provided by Erik Wyand.

subjects (see below). You may also be able to turn the flash in order to bounce its light off of a ceiling or wall, rather than pointing it right at your subject. The result? A quality of light that is softer and more flattering for most portrait subjects.

■ FLASH DISTANCE

Whether built-in or external, knowing how far your flash will travel is important. Many cameras have a scale on the LCD display that indicates the camera's flash range. If yours doesn't, be sure to review your camera's manual to see what limitations your flash may have.

■ RED-EYE ALERT!

Red-eye is caused when light from the flash hits the back of the retina and reflects back toward the camera. Smaller cameras are the worst when it comes to red-eye, simply because the flash is so close to the lens. To prevent red-eye, avoid low-light situations, which cause the pupil to dilate.

Many cameras have a red-eye reduction mode. Red-eye reduction mode creates a "preflash" flicker before the image is captured. This flashing light causes the pupil to constrict, preparing it for the image capture. If your camera

Red-eye is a common problem when using on-camera flash. It can be corrected by using the red-eye reduction setting on your camera or with the help of image-editing software. Photo by Erik Wyand.

does not offer this mode, try increasing the angle at which your flash is hitting the subject by moving closer, or if your camera captures fast enough, take two images—one right after the other. You can also fix the problem post-capture using image-editing software (see lesson 33).

7. EQUIPMENT: LCD PANELS

Perhaps one of the biggest differences between film and digital cameras is that digital models typically feature LCD panels. If you're using a point & shoot camera, you can use the LCD screen to compose your image; SLR users will not be able to access this feature, since on these cameras, the LCD can only be used to review images post-capture. The ability to compose/review images on this little screen is a huge benefit. With film, you couldn't tell whether you got the shot you wanted until you paid for film processing (unless you used Polaroid film).

When reviewing your images, you may be able to achieve a zoomed-in view of an area of the image. This feature allows you to ensure sharp focus in a given area of the image.

Most consumer-model digital cameras have LCD panels that range from 1.5 to 2.5 inches in diameter. When considering a camera, make sure that its LCD panel is large enough—and sharp enough—to show the image clearly.

For some cameras, the various scene modes and other technical settings appear on the LCD screen at the push of a button. Surrounding the LCD are buttons that are used to scroll through and select these features.

Some cameras offer rotatable LCDs. This feature allows you to point your lens at a low or high angle and turn the LCD panel so that you can easily view the scene. As you might have guessed, this is ideal for capturing candid shots, provided you guard against camera shake (see lesson 20).

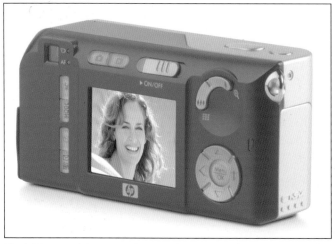

The LCD screen lets you preview your images to make sure you got what you wanted in each shot. Photo courtesy of Hewlett Packard.

8. EQUIPMENT: LENSES

One thing that all cameras have in common is a lens—the mechanism through which light enters the camera and strikes the image sensor, capturing an image when the shutter button is pressed.

■ FIXED LENSES

Some lower-end cameras have fixed lenses that provide only one view of the scene. When using such lenses, you can only obtain a different view of your subject by moving closer or farther from your scene.

■ ZOOM LENSES

Most point & shoot cameras come equipped with a fairly versatile built-in lens that allows you to zoom in (achieve a closer view of your subject without moving your feet) or zoom out (to attain a broader view of the subject or scene). As they are lightweight, versatile, and tend to be economically priced, cameras with these lenses will be the focus of this book.

■ INTERCHANGEABLE LENSES

SLRs, on the other hand, accept interchangeable lenses, so you can buy a variety of lenses for special applications.

For example, you can buy a close-up or "macro" lens to take finely detailed, close-up images of a prominent member of your child's ant colony. You can also buy a telephoto lens to image your spouse at the top of Mt. Everest, while you kick back and relax down below.

These cameras are a good choice for those who want to make a deeper commitment to photography and prefer to have more artistic controls when shooting.

SOME MINIMUM REQUIREMENTS

Though camera technologies are ever changing, at the time this book was published, many nonprofessional photographers were pleased with their digital camera as long as it featured a 3.2MP (or higher) image sensor, a 3X optical view range, and a 3X digital zoom range. By selecting a camera that meets these minimum requirements, you can create quality images indoors and out, up to an 8x10-inch print size!

PHOTOGRAPHY ON THE GO!

Purchase a camera bag that's big enough to hold your camera, lens, flash, batteries, cables, and anything else needed to capture your images! It's a good idea to stash a Ziploc bag in there, too. During a day at the beach, you can slip your camera in it when it's not in use to protect it from sand and water.

■ OPTICAL VS. DIGITAL ZOOM

When considering a digital camera, choose one with an optical and a digital zoom setting. While using the optical zoom is ideal, the digital zoom feature has its place as well.

Optical zoom is defined by www.dpreview.com (a great online resource for information on digital capture) as the magnification factor between the minimum and maximum focal lengths of the lens. Basically, what that means is the lens (rather than your camera's software) magnifies your image to bring you closer to your subject without moving your feet! Look for a camera that offers at least a 3X optical zoom feature.

You can zoom in further on an image using a feature called digital zoom, but doing so will degrade the quality of the image and should usually be avoided. When the digital zoom feature is used, the camera's internal software digitally magnifies a portion of the image and "upsamples" the data, essentially adding pixels to fill out the image. This results in a fuzzier, less sharp image. Look for a camera with a minimum 3X digital zoom range. When need be, you can apply this zoom function to get even closer once you've used the optical zoom to get a better view of your subject.

9. EQUIPMENT: BATTERIES AND CONNECTIVITY

Finally, you embark on your first digital photographic opportunity. You begin to capture fabulous images of your family's day at the beach . . . and then your camera runs out of juice! Why did those batteries die so quickly? While some batteries last longer than others, the truth is, previewing your images on the LCD zaps a lot of power. Also, keep in mind that even fully charged batteries lose power over time if unused, so be sure to have extra rechargeable batteries and a charger on hand at all times. (You may also be able to recharge your battery in your car!)

■ BATTERIES

For digital cameras, rechargeable batteries are a better choice than disposable ones. The NiMH type are more than twice as powerful as the older NiCd type. Also, NiMH batteries have no memory effect, which means that if you recharge them before they are completely drained, you will not reduce their capacity with subsequent rechargings. Rechargeable lithium ion batteries are also available. These batteries have a longer life but are usually more expensive. They are lighter in weight and, unlike NiCd's, have no memory effect. To maximize your battery life, minimize your usage of the LCD screen—this is a big battery drain!

■ CONNECTIVITY

Bundled with your camera, you may find a driver/software installation CD and a cable that will allow you to connect to your computer to download your images. If you currently own a computer that you plan to use for digital imaging, ensure that your computer accepts the cable associated with the camera. Some cable types allow you to transfer images more quickly than others, though this varies depending on the file size, camera type, and numerous other factors.

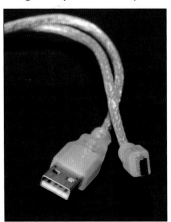

Using a USB cable (left) or FireWire cable, you can connect your camera to a computer or portable hardware device, then download your images. When taking your camera along on a family outing, be sure to bring extra batteries. You wouldn't want your camera to clonk out before your kids do!

10. EQUIPMENT: MAKING A PURCHASE

■ WHERE TO BUY

Now that you have contemplated the camera features that will best suit your needs, it's time to make a final selection. There are many places you can go to purchase the camera that's right for you. From national electronic and retail establishments, to department stores, to specialty camera stores, to online retailers—you'll find many places to shop for cameras that suit your needs. Naturally, you should look for a reputable retailer (see below). A well-trained sales staff or customer-service department can also be a great resource and help you quickly identify models that offer the features you want.

■ BE WARY OF BARGAINS

Beware of pricing that seem too good to be true! Some smaller retail establishments sell "gray market" products. A gray market camera is an imported model that was manufactured outside of the United States with the trademark

Pets are part of the family too! Of course, getting them to tilt their head at the proper angle may take some trial and error!

WHAT YOU NEED

You'll need the following items in order to capture, edit, download, and print your images. We've covered some of these items previously; image-editing software and output devices will be covered in later lessons.

- digital camera
- USB/FireWire cable
- rechargeable batteries and battery charger
- memory card (or two)
- memory card reader
- camera bag
- tripod (for images that require a long exposure)
- photo printer, ink cartridges, and photographic paper
- image-editing software

holder's consent. While these products are not counterfeit, you may find that the printed materials supplied with the camera are written in another language and that the warranty is not valid in the United States. Therefore, while you may save some money on your purchase, you'll pay top dollar for any necessary repairs. Most reputable companies provide a manufacturer's warranty for the first ninety days and then offer a full protection plan for an additional cost.

■ EDUCATING YOURSELF

Because digital technology is ever changing, you'll want to educate yourself on new options on a regular basis (consult magazines like *PC World* or *Consumer Reports* and websites such as www.dpreview.com for helpful information). Be sure to upgrade your equipment and to purchase new accessories as your needs change. Remember, the equipment you select will be used to capture heirloom images your family will cherish for years to come, so choose your equipment wisely.

■ COMPUTER EQUIPMENT

If you're in the market for a new computer, be sure to purchase one that can meet all of your imaging needs. For more information, see lesson 30.

11. BEFORE YOU SHOOT, SET THE FILE SIZE

The image resolution (how many pixels are in your image file) and compression level (how the software organizes that data) that you set your camera to will determine the final size of your image file. Higher resolutions and lower compression levels produce larger files, which are good for producing bigger, better-quality prints. Smaller file sizes and higher compression levels produce smaller files, which are fine for sharing online.

■ RESOLUTION

While capturing images with high resolution can ensure better prints, these files take up a lot of space on your memory card. If you have a high-capacity memory card or multiple cards, this may not be a problem—in fact, you may want to allow the camera to capture images at its default (high-quality) resolution setting. Capturing images at this higher resolution ensures that you can use your images in a number of ways. For example, you can make a quality 8x10-inch print and then use your image-editing program to reduce the file size for online use.

Most digital cameras allow you to select a resolution that is well suited to the intended use of your image.

Super High. This setting allows you to store the fewest images on your memory device. Use this setting to record an image you want to print at 8x10-inches or less.

High. A mid-range resolution is great for creating wallet-size prints. It's good for producing 4x6-inch prints and is okay for 5x7-inch prints.

Medium. This setting allows you to produce acceptable 4x6-inch prints.

Low. This low-resolution setting allows you to capture the largest number of images on your memory device. Select this setting when you want to create digital slide shows, post photos on websites, or e-mail images to a friend or relative. With this resolution, you won't be able to create prints larger than wallet size.

■ JPEG COMPRESSION LEVELS

To more efficiently store data on its memory card, your camera compresses each image file. The upside is that this action allows you to capture more images; the downside is that JPEG compression is "lossy." This means that, during compression, some pixels are thrown away, and the lost data cannot be

reclaimed. For this reason, you'll want to select a compression level that is suited to the intended use of your image.

Super Fine. This lower compression level allows you to maintain larger image files. Select this compression setting if you plan to make prints of your photographs to share with your family and friends.

Fine. This mid-range compression is good for everyday image capture and allows you to work faster. It's also fine for most smaller printing needs (under 8x10 inches).

Normal. This is the

When enlarged beyond the recommended size, your image will lose detail, as seen here in the girls' faces and eyes. The image would likely reproduce well as a 4x6- or 5x7-inch image. Image by Stephanie Moore.

highest compression level and will allow you to store the greatest number of images in your camera. The smaller file size is appropriate if you want to e-mail photos to friends, host a web gallery, or design online albums.

■ RAW MODE

When you shoot in RAW mode, you get an uncompressed image, meaning that every bit of your image data is maintained. To download and edit RAW photos, you must use special software. If your camera allows for RAW capture, the installation CD will include the necessary software. With other software products, check the help files to see if the program is equipped with a RAW file reader. If not, you'll need to buy a plug-in (see lesson 32).

12. COMPOSITION, PART 1

Composition is the artful arrangement of everything—the lines, colors, shapes, subject, etc.—in a scene. When we compose an image, we want to be sure that our subject is featured prominently, that there are no distracting elements in the frame, and that the image has a soft of visual rhythm that makes it appear more artistic than random. The following tips will help you to create better-composed photographs that will help you communicate to the viewer and hold their attention.

While photographic guidelines can work to your advantage, be flexible and consider the qualities of your subject before blindly following any rules. Experiment. You may be surprised at what you create in the end!

■ SUBJECT PLACEMENT

Most amateurs capture their images horizontally with the subject dead-center in the frame; this results in a static, nonstimulating image. Most professionals rely on the Rule of Thirds to craft effective images. To use it yourself, picture a tic-tac-toe grid superimposed over the entire scene (see facing page), and position the main subject at any of the four points (often called "power points") where the vertical and horizontal lines intersect.

Of course, there are exceptions to every rule. Therefore, there are times when you'll want to disregard the Rule of Thirds. For instance, a central placement can be effective when showing symmetry in a subject—say, when you want to take a picture of your family cabin and its reflection on the lake.

■ PERSPECTIVE

Most people take pictures while standing and fail to tilt the camera. While it is possible to capture many good images this way, sometimes a change in perspective can make all the difference. To change perspective, shoot from the ground looking up, or from high above looking down. Grab a photo of your kid from their level. Tilt the camera like you would tilt your head to study a fascinating work of art—then make your image that way.

■ HORIZONTAL OR VERTICAL?

As a rule of thumb, horizontal subjects (like seascapes) should be photographed horizontally, and vertical subjects (like people) should be photographed vertically. However, breaking that rule can sometimes be effective.

Everything in this picture points to the baby's wonderful expression. The child's face is slightly off center for a more dynamic composition, and her arms—and even the light wrinkles in the blanket behind her—form diagonal leading lines that draw your eyes to her face. Photo by Erik Wyand.

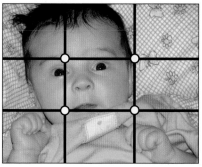

For instance, you might consider shooting a close-up group portrait with your camera positioned horizontally to capture an effective image.

■ LEADING LINES

Leading lines can also draw attention to your subject. For instance, a playhouse door makes a great frame for your toddler. A curved road can direct the viewer's gaze to the little house at the end of the street, etc.

■ ARMS AND LEGS

When composing portraits, take a minute to make sure that arms and legs aren't cut out of the frame in an unflattering way.

13. COMPOSITION, PART 2

■ BACKGROUNDS

Very bright or dark areas of any background will draw attention away from your subject, while simple, neutral backgrounds will allow the viewer's gaze to rest on the subject. If you can compose the image in such a way as to minimize the background space in the image, you can alleviate concerns over distracting elements. Consider shooting from a higher- or lower-than-normal angle and/or using a wide aperture (see lesson 14) to help eliminate distracting elements.

Very bright backgrounds, like this washed-out sky, can distract from your subject (left). Composing the image so the background is less distracting produces a better image (below and facing page). It's especially helpful if the background is at least a little out of focus.

14. EXPOSURE, PART 1

To produce a properly exposed image, the camera's sensor must be exposed to just the right amount of light. When your camera is set in the automatic mode or in one of the scene modes (see lessons 16 and 17), the camera makes some or all of the required adjustments for you. When you work in the manual mode (see lesson 17), proper exposure depends on the settings you select. Lessons 14 and 15 cover the terms you need to know if you want to use anything other than the automatic mode. Don't worry if these seem a bit confusing—just refer back to this section as you continue through the book.

■ SHUTTER SPEED

The shutter speed setting dictates *how long* light is allowed to strike the image sensor. For properly exposed images, the shutter speed will need to be on the shorter side (usually a small fraction of a second) in bright-light situations. In low-light scenes, a longer shutter speed (maybe as much as second or more) comes in handy—as does a tripod!

Creative Applications. Using a fast shutter speed will also allow you to freeze action in moving subjects; a slow shutter speed allows you to blur moving subjects.

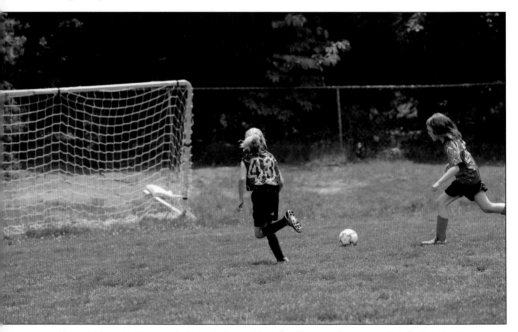

Use a higher shutter speed when photographing sporting events or any other fast action!

At a wide aperture setting, the background blurs out. This helps to keep the viewer's attention on the intended subject.

■ APERTURE

The aperture setting dictates *how much* light is allowed to strike the image sensor. The aperture is an opening in the lens that allows light into the camera. The diameter of this opening is measured in f-stops, with a wider f-stop, like f2.8, allowing in more light than a narrower f-stop, like f22. In low-light situations, using a wider aperture setting will allow more light to strike the sensor during the amount of time determined by the shutter-speed setting.

Creative Applications. The aperture setting also determines the distance range within which subjects will appear sharp in the final print. This is called the depth of field. When a narrow aperture is selected, the range of sharpness is large—from the foreground to the background, a great deal of your scene or subject will be in sharp focus. When the aperture setting is wider, the range of sharpness is smaller—this means that some of the scene or subject will be sharp and some will be at least somewhat blurred. When the background is an important part of the image, you'll want to consider a narrow aperture. When you want to blur the background, say to make a person stand out better from a cluttered setting, select a wider aperture. (Use the manual mode or the aperture-priority scene mode to make these choices—see lessons 12 and 19.)

So how are you supposed to know what settings to choose? Read on!

15. EXPOSURE, PART 2

◾ ISO

The ISO setting dictates *how sensitive* to light the image sensor will be. If you are photographing your child in a low-light interior, you will use a higher ISO (typically, 400–800), so the image sensor will be quite sensitive to light. However, if you are outside in a bright-light situation, a lower ISO range would be sufficient (typically, 100 and above). Often, the higher the ISO, the more noise (a grain-like pattern) will appear in the image.

◾ LIGHT METERS

Digital cameras feature a built-in light meter, a device that measures the light falling on a scene and recommends a particular aperture, shutter speed, and ISO combination that will result in proper exposure. This meter is designed to produce optimal results in average scenes—scenes that are neither very dark or very bright (for tips on these scenes, see below). When you shoot in the automatic mode, the meter tells your camera how to set the ISO, shutter speed, and aperture. When you shoot in the manual mode, it will tell you whether the settings you've chosen will provide a good exposure. Since meters vary from model to model, consult your camera's manual to see how yours works, if you plan to shoot in the manual mode.

◾ EXPOSURE COMPENSATION FOR TRICKY SCENES

In scenes that are predominately light or dark, the camera's light meter may be fooled and you may wind up with an overexposed (too light) or underexposed (too dark) image.

Very light and very dark scenes can cause exposure problems (left). Exposure compensation can cure the problem (right). Image by Angi Aveyard.

Imagine that your child is bundled up in a white, hooded snowsuit and wants to dive into the snowbanks in your yard. When he starts to pack his first snowball in his gloved hand, you pick up your camera to "freeze" the moment—and you eagerly take a series of shots. Well, without exposure compensation, your camera

When working in low light situations, adjusting the exposure compensation setting can help ensure accurate exposures.

would overexpose the scene and render your winter wonderland as a rather dingy, gray scene (as seen on the facing page).

Most cameras feature an exposure compensation feature that will allow you to get proper exposure when you're shooting an image comprised of primarily light or primarily dark tones. For a primarily light image, you may want to select an exposure compensation value of +1. For a shot of your family's black cat swinging on your teenage daughter's black velvet curtains, you might choose a setting of −1.

There may be times, of course, when a scene is a little less white or dark (or a little more so) than in the above examples. Select a promising exposure compensation value, take a shot, check your LCD monitor, and repeat as necessary. The beauty of digital is that there's no cost associated with taking images until you get them just right!

16. SCENE MODES, PART 1

Most digital cameras offer a variety of scene modes. Consult your camera's instruction manual to discover the options!

■ AUTOMATIC

Set in this mode, the camera makes all of the critical exposure decisions for you. You won't have to determine whether you should adjust your shutter speed and aperture (see lesson 14), or whether or not you'll need flash to brighten things up a bit.

■ PORTRAIT

When shooting in this mode, the subject will be imaged in sharp focus and the focus behind the subject will gradually fall away. This setting can be used effectively for any subject—human or otherwise.

■ LANDSCAPE

Unlike the portrait mode, this setting should be used when you want a wide range of focus (or "depth of field") in your image. Use a tripod, since the shutter speeds can be long.

■ NIGHT PORTRAIT

When you select this mode, the camera's flash will be activated to illuminate the night scene. The shutter speed, which is typically synchronized to the duration of the illumination, becomes a bit longer in order to register any light source in the scene (streetlights, campfire, etc.).

This image was captured in portrait mode at an ISO of 200. Using a red-eye reduction feature would have helped prevent red-eye. All is not lost, however. The red-eye can be removed using an image-editing program. Photo by Tom Chuparkoff.

Many digital cameras allow you to switch back and forth between color images (left) and black & white, sepia (right), and other colors. If yours doesn't, you can achieve the same effect using digital imaging software. Photo by Loretta Wall.

◼ PANORAMIC

Use this mode to create a series of overlapping shots that can be "stitched together" using image-editing software to make longer- or taller-than-normal images.

◼ CONTINUOUS

When you select this mode, your camera will continuously capture images so long as the shutter button is pressed. Use it to capture Johnny as he dives off the high dive, and you'll not only capture him in various stages of his dive, but you'll also improve your chances for capturing the point of contact with the water.

◼ ARTISTIC EFFECTS

As seen in the photos above, some cameras allow you to shoot in various color modes, like sepia or black & white. Some photographers prefer to achieve these effects in the computer, so all is not lost if your camera lacks this option.

17. SCENE MODES, PART 2

■ PROGRAM

This mode is similar to the automatic mode but allows you to select some of the settings (ISO, white balance, etc.; see lessons 15 and 18). The program and automatic modes can be used to capture quality images. However, they don't always produce ideal results. When you're comfortable with your camera, make your settings manually or use one of the modes discussed below.

■ SHUTTER PRIORITY

This mode allows you to select the best shutter speed for the scene you are shooting. The camera automatically selects a complementary aperture setting.

■ APERTURE PRIORITY

In this mode, you select the aperture and the camera chooses an effective shutter speed.

■ MANUAL

Because you adjust all the exposure settings, working in the manual mode allows you to flex your creativity to capture images that really shine. With the appropriate settings, you can blur Kelsey as she surfs that twenty-foot wave,

traveling at lightning speed—or use a fast shutter speed to stop her in her tracks. You can also overexpose the shot to visually emphasize the effects of that white-hot Hawaiian sun.

Working in the manual mode also allows you to make technical decisions to create great pictures in a variety of lighting conditions, to precisely control your depth of field, and to reduce the danger of camera shake (and thus, blurred images) by selecting a fast shutter speed.

A fast shutter speed lets you freeze even fast action (left and facing page).

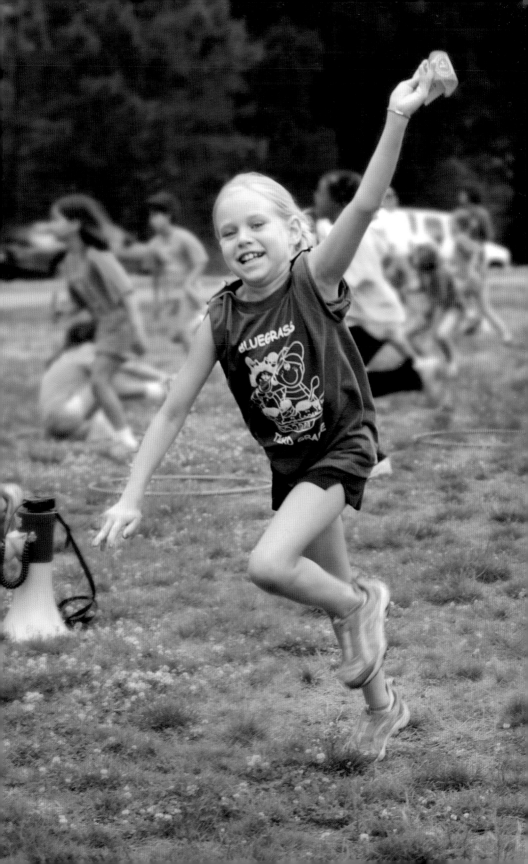

18. WHITE BALANCE

Unlike our eyes, cameras cannot compensate for the effect that various light sources have on the colors in a scene. As a result, the digital camera needs a reference point for determining what should be recorded as white (and how the other colors in the scene should correspond). Without this critical white-balance feature, each shot taken under household lighting would have an overall yellow color cast.

While the auto white-balance feature works pretty well in the average scene, it's definitely not foolproof. Therefore, you'll want to choose another white balance mode—like tungsten, daylight, or fluorescent—if your scene has a predominant color or does not contain any white elements.

Household lighting can cause a yellow color cast (above). Switching to the tungsten white-balance setting compensates for this to produce more accurate colors (facing page).

Not all color casts are objectionable. At dawn and sunset, the golden tones in the light are quite beautiful for portraits. Using a daylight white-balance setting will help you capture these warm colors. Image provided by Mary Ellen Nelson.

19. OTHER CAMERA FEATURES

■ SELF-TIMER

If you're the designated family photographer and you'd like to appear in your images, use the self-timer. This feature allows you to compose an image (say, with the camera mounted on a tripod), then gives you some time to move into the frame. The quickening pulse of a light on the front of the camera typically alerts you that the shot is about to be captured. Consult your camera's instruction manual for details.

■ VIDEO

Furthermore, many cameras offer a minimovie feature that allow you to capture short sessions of motion and sound. This feature cannot (as of this writing) compare to a camcorder, however. Digital cameras typically record only fifteen to thirty seconds of video and have a much lower resolution

Using a self-timer, you can set up a shot and get into position before the shutter clicks.

20. TEN TIPS FOR IMAGING SUCCESS

The following recommendations will help you to create the best possible images.

■ TEN TIPS FOR IMAGING SUCCESS

1. **Eliminate Camera Shake.** When shooting a scene from far away, camera shake is a real concern. Consider investing in a lightweight, easy-to-use tripod. These can be purchased for as little as $25 from many camera stores nationwide. If you don't have access to a tripod, try placing your camera on a tabletop, fence, etc. Likewise, leaning against a wall or sitting with your elbows on your knees will help you to create a more stable base for your camera. Also, try placing your left hand under the camera to support it, and hold your breath while you gently squeeze the trigger.

2. **Keep Your Fingers Out of the Picture.** Be sure you don't get your fingers or camera strap in the way of the lens. This is especially important with small point & shoot cameras.

Hold the camera from the bottom to prevent blocking the flash or the lens and to discourage camera shake.

To eliminate camera shake and a blurred image, lean against a wall or other object to keep your camera steady.

3. **Compose Your Image Carefully.** Try placing your subject at one of the power points in the image (see lesson 12). With an autofocus lens, lock your focus on the subject as described in lesson 21 before recomposing the image and capturing the shot.

4. **Avoid Reflections.** When photographing reflective objects, shoot at an angle to avoid a reflection from the flash.

5. **Experiment with Scene Modes.** Play with different scene modes and camera settings.

6. **Try a Different Angle.** Shoot from low or high angles to get the best possible image.

7. **Avoid Constantly Reviewing Images.** Resist the urge to constantly check your LCD screen. This can drain your batteries and leave you out of juice to capture the rest of your images.

8. **Shoot Some Verticals.** Don't just photograph horizontally, photograph vertically as well.

9. **Get Down Low.** Get down to the child's level for the best perspective.

10. **Check the Lens Cap.** Don't forget to remove the lens cap!

21. PORTRAIT IDEAS

A portrait can be defined as an image of a subject (often making direct eye contact with the camera). It can be composed as a head-and-shoulders image (showing the subject down to the upper chest), a mid-length portrait (showing the subject down to the hips or mid-thigh), or a full-length image (showing the subject from head to toe). These images can be candid or posed. When possible, utilize the following tips.

1. Get a Natural Look. Have your child sit or lean against a wall or tree for a more natural-looking posed portrait.

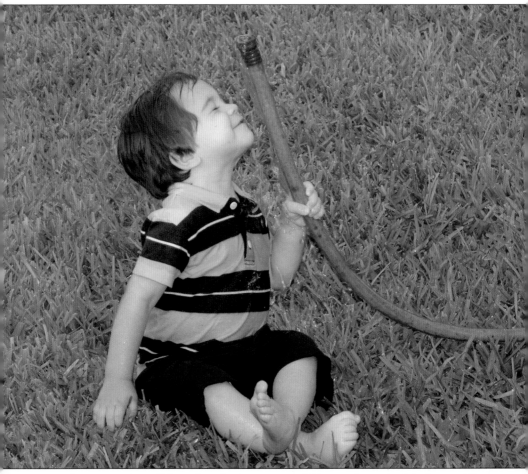

Erik Wyand's photo of his son in action is a great candid image. The angle of the hose and the perfect twist of the subject's little feet make for a great composition, and the expression on his face shows how much fun he had on this hot summer day!

2. **Pose at an Angle.** Avoid photographing your child straight on. Pose their body at an angle to the camera and turn the head at a slightly different angle.

3. **For a Flattering Look . . .** If your child or spouse has a round face, have them turn their head slightly away from the camera. Have them face the camera straight-on if their face is thin. If they have a double chin, ask them to "turtle" slightly, sticking their chin out. The chin should be out, not up!

4. **Get Close.** The object of interest in a portrait is the face. Make it a prominent part of the image. To make sure your subject's eyes are sharp, position the focus indicator over the eyes, hold the shutter button down halfway, re-compose the image as necessary, then fully press the shutter button. This ensures that the focus is locked on the original point of focus. If your subject is close to the lens (say, less than three or four feet away), you may need to use your camera's close-up feature (usually indicated by a flower icon) to ensure sharp focus. Also, if your child tends to blink a lot ask him to look down, then look up at the count of three—then snap the picture.

5. **Get Closer Still.** Use your camera's close-up feature to snap an image of your daughter's tiny fingers curled around her dad's. Take a picture of the soles of your kids' feet when they're lying in a row in the sand—and do it so that their feet fill most of the frame. Is this a "portrait" in the traditional sense? Maybe not, but it sure makes for a special image.

6. **Eye Contact and Smiles.** Don't insist that your child look at the camera or smile. Some of the best images are made when the child looks deep in thought or quietly pleased. You might even try a shot of your son or daughter wandering down a garden path, facing away from the camera.

7. **Avoid Backlighting.** When shooting outdoors, make sure that your child is not positioned between the sun and your lens. This will result in dark shadowing on his or her face.

8. **Candids.** Candid images show your subjects unposed and acting naturally. These images can show us something about the subject—perhaps displaying a great expression or engaged in a favorite activity. You'll need to capture these images quickly and from a distance using your camera's zoom feature.

22. GROUP PORTRAITS

■ POSING

With a group image, there should be a visual connection among the members. You can achieve this by having everyone touching in some way or by having the subjects wear similar colors. Be sure you never chop off a body part; zoom out far enough to get the arms and legs of everyone in each image. When possible, have everyone positioned so their heads are at different levels (and always make men taller than women). This helps you create a more dynamic composition.

Get creative when photographing a group of people, whether you want a traditional image or one that's more unique.

■ CLOTHING

Your family member(s) should be the main focus of the image. However, many people select clothing that pulls the viewer's eye away from the subject!

When choosing clothing, avoid bright colors, logos, patterns (even stripes), and clothes that "date" an image (meaning you won't want to display the image in a few short years). Solid, neutral colors look great in images, keeping the viewer's eye on the subject's face. Plain t-shirts, button-downs in solid colors, khakis, jeans, and simple dresses are popular choices.

When working with a group, color harmony is important. If you're planning a family reunion, why not order up a bunch of t-shirts so clashing colors aren't a problem in your image? Again, a sense of cohesiveness among the group members is important to a successful image.

23. DISTRACTING ELEMENTS

Many people take images quickly and often fail to realize how the elements in a scene will shape the final image. For the best results, try to do a visual check of the subject's surroundings and eliminate distractions. By changing the person's position or the camera angle, you may be able to avoid placing a horizon line in such a way that it seems to cut through your subject's neck or a tree branch so that it appears to sprout from their head—you may also be able to eliminate distracting colors or clutter. If the above suggestions won't work, consider using a wider lens setting and a wider aperture to blur the background.

Lydia Horan took this beautiful image of her son Michael (above). His big, blue eyes pop off the page! Look for and eliminate any distracting elements to make your portraits even better. If Michael's sleeve had been slightly adjusted so it wasn't covering his mouth, this image would have been perfect! When photographing a group against a scenic background (facing page), consider the point to which a viewer's focus will be drawn. In this image, captured in downtown Chicago, the viewer's eye is drawn to the picture on the building to the right. In this case, that makes for a really cool capture. However, if the photographer's goal was to capture and focus on the three people in the middle, then the background would be too distracting. In such a case, zooming in for a closer view of the subjects could be helpful. Photo provided by Virginia Infante.

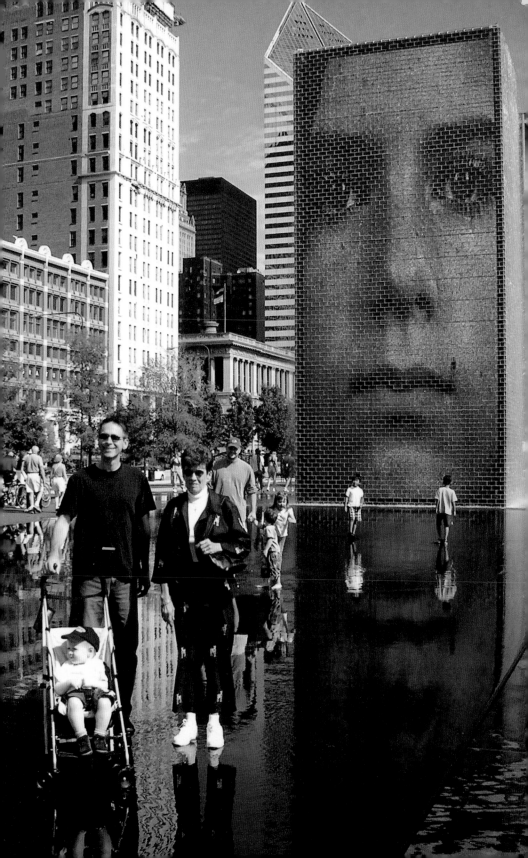

24. OUTDOOR LIGHTING

■ TIME OF DAY

The best time to photograph subjects outdoors is from one hour before until one hour after sunrise and from one hour before sunset until sunset.

Unless you can position your subject in a shaded area—say, under an overhang like a tree or the roof of a porch—shooting during midday can produce harsh, unflattering shadows. In portraits, these may appear under the subject's eyes, nose, and lips.

Take advantage of the light available on overcast days. In overcast conditions, the light is soft and indirect, and colors in the scene appear rich and saturated.

■ BACKLIGHTING

It is best to avoid backlighting (a lighting situation where your subject is between you and the light source) when possible, as light will fall behind your subject, leaving your subject in shadow or underexposed in the final print. Adding flash or setting your camera to a fill flash setting (if available) may remedy the situation.

■ FLASH

For optimal results, use flash when photographing people outdoors. You will add sparkle to their eyes and help eliminate shadows. Know first, though, how far your flash will travel!

The golden glow of evening light makes it great for portraits. Image by Erik Wyand.

25. INDOOR LIGHTING

No matter how lovely your interior, the subject of the image should draw the viewer's attention in the final image. Rather than posing your son against grandma's cabbage-rose drapes, try to choose a less commanding spot, without strong lines or distracting colors, then fill your frame with as much of your subject as possible.

When working indoors, you'll often need to rely on your flash to ensure proper exposure. If your camera allows, angle the flash to bounce light off of the ceiling or a wall for softer, more flattering light. If your camera's flash cannot be rotated, then photograph your subject away from walls, where heavy shadows can form behind him or her.

◼ WHITE BALANCE
As noted in lesson 18, cameras cannot compensate for the effect that various light sources have on the colors in a scene. To avoid creating an indoor image with a color shift, adjust the camera's white balance setting to automatic or

Simple backgrounds help keep the focus on your subject. Photo by Erik Wyand.

Don't pack your camera away just because it's not a "special" occasion—keep it handy around the house for all those funny, sweet, or memorable little moments that arise every day. Photo by Tom Chuparkoff.

tungsten (represented by a lightbulb icon) when lighting the image using household bulbs.

■ WINDOW LIGHT

Window light is a beautiful option for many photos. To create a softly lit, flattering portrait, use window light on overcast days and position your family member so that half to three-quarters of his or her face is illuminated.

Try setting your white balance to the auto setting or, since your subject will likely be lit by a combination of natural and artificial light, you can create a custom white balance setting. Check your camera's manual for instructions.

■ BACKGROUNDS

While your walls can certainly make a nice backdrop, you might also want to consider hanging a solid-colored panel of fabric behind your subject. This can add versatility to your portraits and allows for more creative expression, as well. Be sure to choose a color that does not command too much attention. Also, be sure that the person's clothing and hair contrast with the background color for the best results.

26. BABIES (0–6 MONTHS)

From their first bath to their first crawl, your child will experience many landmark moments you will want to digitally document. My best advice is: capture, capture, capture. You can never capture too many images! Luckily, with your digital camera, you can record all these precious highlights in your child's life—in the most cost-effective manner!

■ HOMECOMING
There's nothing like the birth of a baby to spur a parent's desire to create special photos—and there's no better place to start!

Capture images that document baby's birth and homecoming. Encourage Dad to delegate his picture-taking responsibilities today—he may be too caught up in the action to capture those special moments!

■ NEWBORN TO 3 MONTHS
At this age, capture images indoors using window light (not flash!), it's less disruptive for the child. Also, avoid fancy outfits. Too much fabric can obscure those precious little arms, legs, fingers, and toes and can detract from the image. Images of newborns in their birthday suits are charming. For many families, close-ups of baby with a parent are another favorite shot.

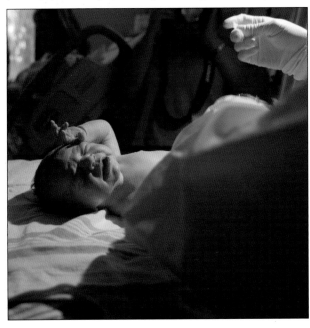

Consult with your physician prior to your delivery date to determine the rules and regulations for photography in the hospital or during the delivery. In addition to taking still shots, you might want to appoint someone to videotape the special delivery!

Avoid using flash when photographing newborns for softer, more natural lighting. Also make sure that the background isn't too distracting. A white blanket, towel, or table cloth may make a better setting than a printed sheet or pillow.

■ 3 TO 6 MONTHS

These photos are still best captured in the comfort of your home. At this stage, babies can sit up, so posing in a rocker, on a bench, in a swing, or on an Adirondack chair works best. Select clothing that suits your child's personality. Your child is older and taller, so denim overalls and frilly dresses are now great wardrobe choices. Try to capture a sequence of images and display them in a multiple-image frame.

DOCUMENT THEIR GROWTH

Babies triple their birth weight in the first year of their life! Digital technology allows you to capture their growth. Photograph your tiny loved one once a month for the first year and then three to four times a year each year after that. Create both head shots and full-length body shots to show your child's growth.

27. BABIES (6–12 MONTHS)

■ 6 TO 9 MONTHS

Your child is growing and changing daily and is beginning to adapt to the outside world. The 6–9 month photos can be made inside or outdoors. At this point, your baby can stand up by leaning on stairs, against a fence, a chair, or any other prop. At this age, your child's personality will begin to shine through in the image. Use a noise-making toy to grab your child's attention for portraits, but capture candid images too. Be sure to capture their first walk, first day at the beach or park, or other fun new venture.

Using a chair, walker, or other prop in the image will show how your child is growing and gaining independence!

At 12 months, your child is likely walking solo (left). Be sure to document this newfound independence! Your baby is also becoming more expressive at this age. Be sure to push the button when the expression begins and not when it ends (right)!

■ 12 MONTHS

At this age, you'll probably want to photograph your child's first birthday—not to mention trips to the zoo, the park, etc. Look for scenic spots in your community—a park with ducks, a beach, etc.—and make a photo trip. Because most babies start to walk at this age, on-location images are a great option.

The first year of a baby's life is the most important one to document, because their personality and looks change so fast. After the first year, consider scheduling yearly portrait sessions with a professional photographer and capture the rest of the highlights yourself.

To visually chronicle your child's development, schedule time to take pictures at least three or four times a year. In our busy lives, it's easy to let months slip by without documenting our children's accomplishments. If you make picture-taking a planned part of your schedule, you'll find it much easier to create a visual history of these once-in-a-lifetime stages.

28. SPECIAL EVENTS, PART 1

■ HOLIDAY/BIRTHDAY PORTRAITS

The holidays have traditionally been a good excuse for people to capture images of the ones they love. They make great e-mail updates, holiday cards, and gifts for friends and families. Before you blink, your toddler won't be toddling anymore. Make it a point to start a tradition and create a family portrait

For special events, like birthdays, the goal is to capture images that are full of emotion. Get up close and personal!

every year at your holiday gathering. Think beyond your immediate family and make a date with extended family members as well.

◼ SWEET SIXTEEN

To mark your child's growing maturity and move toward adulthood, be sure to capture images at this age—if for no other reason than to remind him or her how much trouble they were when they were a teenager!

The holidays or family gatherings are a good time to get a group portrait of the ones you love (above). An image of Grandma with her grandchildren is always a treasured classic. Photo provided by Virginia Infante. Be sure to document your teenager as he/she begins to blossom into an adult (right)!

29. SPECIAL EVENTS, PART 2

■ RELIGIOUS/CULTURAL EVENTS

Photograph your child's baptism, first communion, bar/bat mitzvah, mis quince anos, etc. Consider displaying the images in albums or frames.

Before you shoot, determine whether photographing a ceremony is permissible and whether or not you can use flash (above). Capture images of your high-school senior on their way to a dance—don't just wait to take pictures at graduation (right)! If photographing outdoors, consider bumping up the flash to add sparkle to the eyes (facing page).

■ GRADUATION

Sure, schools will provide some sort of graduation image for an announcement and yearbook photo. However, no one will document your new graduate's personality and this important moment in their life better than you can. Take notice of what is important to your teen right now. Don't judge or lecture, just document. Are you capturing their letter jacket, car, instrument, uniform, or anything else that represents their personality and style? These images will not only be an heirloom for you, but for them one day too.

30. COMPUTER EQUIPMENT

■ COMPUTER

If you're in the market for a computer, consult with a professional to ensure that a given model meets your digital imaging needs. Here are some questions that will help you to identify a good match:

1. Do we need to upgrade our current computer?
2. How much RAM, hard drive space, and processor speed will we need to process our files?
3. What features do we need to run the selected software?
4. Are we going to store and save all of our images on the hard drive, burn them to a CD (or other storage device), or both?
5. Will we be able to upgrade the computer at a later date?
6. What printer will we need to purchase to print our images and make gift cards and other photo projects?
7. Does the computer come with instructional materials and a warranty? Will any training be available?
8. Will a high-speed modem be required to work with larger image files?

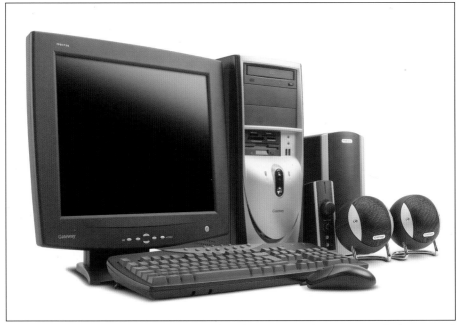

Whether you choose a Macintosh or Windows-based system, your home computer is the center of your digital darkroom. Photo courtesy of Gateway.

When purchasing your computer, be sure to get the fastest processor and highest amount of RAM you can afford. You may also want to purchase a portable hard drive or a laptop so you can download your images while on family outings.

■ MONITOR

A quality monitor is crucial for photographers who want to fine-tune their photos using image-editing software. Most newer monitors offer high enough resolution to provide you a sharp view of your image. Choosing a monitor that's 17 inches or larger in diameter will allow for the best view of your images.

■ CD/DVD BURNERS

CDs and DVDs (whether rewritable or designed for one-time use) are great storage options for your image files. If you routinely save your images on disc, you'll free up a lot of hard drive space. Consider purchasing a CD/DVD burner if your computer isn't equipped with one.

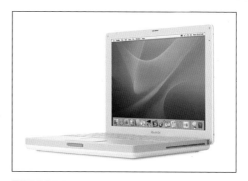

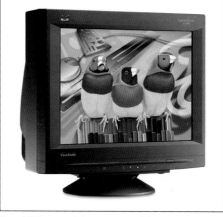

In addition to giving you a quick way to upload your photos, you can use your laptop's CD/DVD burner to make daily backups while you're on vacation—and get online to e-mail pictures back home (top). Photo courtesy of Apple. A quality monitor is crucial for photographers who want to fine-tune their photos using image-editing software (above). Photo courtesy of Lacie.

TAKE OUT THE TRASH

Don't be a pack rat! Delete the image files that you don't intend to use—they hog computer space!

31. DOWNLOADING IMAGES AND BACKING UP

Many photographers enjoy working with image-editing software to crop images for improved composition, to remove red-eye, eliminate distracting elements, and correct poor color rendition or exposure in their digital images. The truth is, there are countless uses for image-editing programs and the more sophisticated the program, the more extensive the options. Of course, you'll need to download your images before you can make any such corrections.

■ DOWNLOADING

Before you can edit your images using the appropriate software, you have to get the images out of your camera and onto your computer. Once your image

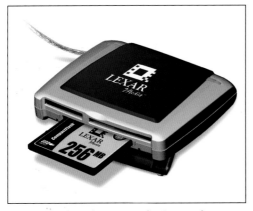

Using a card reader to transfer images from your digital camera to your computer is often easier than having to attach the camera to the computer with a cable each time. Photo courtesy of Lexar Media.

is stored in the camera, you can transfer it to your computer in one of several ways.

USB/FireWire. By simply connecting one end of a USB or FireWire cable to your camera and the other to your computer, you can easily download some or all of the images from your memory card for on-screen viewing, image editing, and storage.

Card Readers. You can also copy your images to your computer's hard drive by using a card reader. These are built into the towers of some computer systems and can also be purchased separately at an electronics store. In either case, be sure that your particular camera's memory card can be used with the reader, as the dimension of each card format varies.

■ CREATING IMAGE BACKUPS

Whether the failure is hardware related, software related, a result of human error, or due to a natural disaster, the number of data loss events will increase as families rely more on technology to store their memories. Follow these tips to protect your digital images.

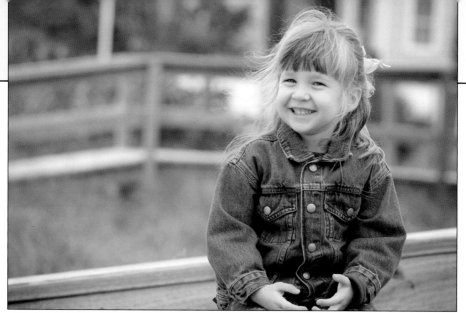

Don't risk losing precious images. Make backups of your files as soon as you download them from your memory card.

1. Back up your images by burning a CD or DVD immediately following the download. Without a backup, a hard drive failure or a computer virus could destroy your only copy of your cherished images. Occasionally, lost or damaged files can be rescued, but this expense and trouble can be easily avoided by saving the files to a disc.

2. Copy the files from your memory card rather than moving them. If you move the images and there is a power surge or computer glitch in the process, you could lose your images. If you are copying them and there is a glitch, you can simply start all over again. Once they are copied onto your computer, make sure that each captured image was downloaded. Next, open each file from the disc to make sure that each photo opens. This takes time. Be patient and do not take costly shortcuts. Once you're sure that the images copied correctly, you can delete the images from your memory card.

3. CD-Rs have a shelf life of up to ten years, so update your archives regularly or print your important images using archival papers and inks.

4. Perform a valid backup before making any hardware or software changes to your system.

5. If your computer or drive is making unusual noises, turn it off immediately and call a recovery company or computer technician for assistance.

6. Add your computer system and digital camera to your homeowner's insurance policy!

32. SOFTWARE

■ IMAGE-EDITING SOFTWARE

It's never been easier to resolve problems in images. If your camera came equipped with an image-editing CD, you can install the program on your computer and make some basic corrections—like red-eye correction, cropping, and image rotation. For how-to tips consult your instruction manual.

Third-party programs offer more options for image enhancement. The most sophisticated program commonly used by amateur photographers is

Adobe Photoshop Elements, which will allow you to make all of the above-mentioned corrections and countless others. For example, you can apply a host of digital "filters" to recreate a watercolor or colored-pencil effect, to "tear" the edges of the print, and much more. Image resizing—whether to produce specific

Adobe Photoshop Elements (left) is the most sophisticated image-editing program commonly used by amateur photographers. Photo courtesy of Adobe. Many beginners also like Apple's iPhoto software (below), which is especially useful for organizing photos. Photo courtesy of Apple.

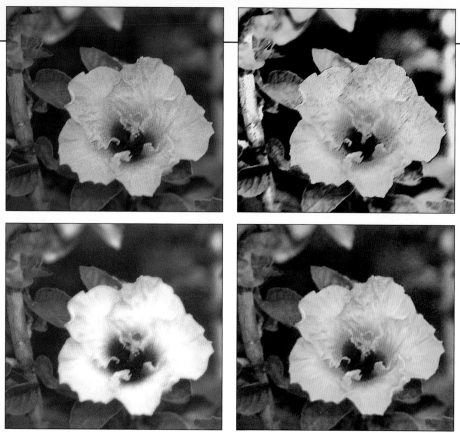

In Adobe Photoshop Elements, you can quickly apply filters to create unique new looks (top right, bottom left and right) from your original image (top left).

print sizes or to prepare images for use on the web—is another option. You can download a free trial version to get started. Just go to www.adobe.com.

Apple's iPhoto and ACDSee are two other programs that are popular with beginners. Consult the latest photo magazines, browse websites, and check out books on the subject to learn how to put these powerful tools to work for you!

■ PLUG-INS

Plug-ins are specialized programs that are installed in a host program like Adobe Photoshop Elements and amplify your image-editing capabilities. There are countless such programs available on the market, with varying price points (from free on up). For more information on the many effects you can produce, see Jack and Sue Drafahl's *Plug-ins for Adobe® Photoshop®: A Guide for Photographers* (Amherst Media, 2004).

33. BASIC IMAGE ENHANCEMENTS

While it is beyond the scope of this book to cover all the things you can do with your images using image-editing software, the following are some common operations. How each is accomplished will vary somewhat depending on the software you use, but the basic techniques described are typical and give you an idea of the types of changes you may want to make.

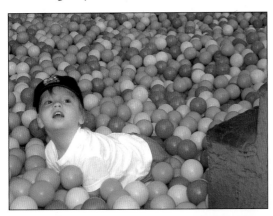

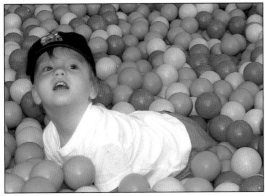

With digital-imaging software such as iPhoto or Adobe Photoshop Elements, cropping an image to remove distracting elements and keep your focus on the subject is quick and easy. Image by Lynda Farquhar.

■ IMAGE ROTATION

When you tip your camera on end to take a vertical picture, you'll need to rotate that photo after the shoot in order to view it properly. This is usually accomplished via a rotate pull-down menu or button that allows you to turn the photo 90 degrees clockwise or countercockwise.

■ CROPPING

Cropping means removing extraneous detail from the edges of the photograph to improve the composition and eliminate things that distract the viewer from the subject. In most programs, you'll select a cropping tool, then click and drag with your mouse over the area of the image you want to keep. When you hit OK or Enter, everything outside the area you selected will be removed.

■ RED-EYE REDUCTION

Red-eye is so common in portraits taken with flash that most consumer digital-imaging programs contain a special tool for removing it. With most, all

With digital-imaging software, red-eye can quickly be eliminated. Photo by Erik Wyand.

you need to do is select the tool, then click one or more times on the red area of the eye.

■ COLOR AND EXPOSURE CORRECTION

Even with LCDs to preview your images, sometimes you don't get quite the right color or exposure. Most image-editing programs contain automatic tools, usually accessed via a pull-down menu, to correct the color and contrast of your images. If you want more flexible control, look for a program that provides some manual controls as well.

Exposure and color problems can sometimes occur, but they are usually corrected very easily using digital-imaging software. Photo by Erik Wyand.

34. SAVING EDITED IMAGES

As discussed in lesson 11, your digital camera will save every file you shoot in a compressed format as a JPEG file. This is a necessary evil; although it can compromise the image quality, it also maximizes the number of images you can shoot before you have to change memory cards (or delete files from your card).

Once you have uploaded and backed up your image files, however, you should convert them to a file format that uses no compression. Why? Well, every time you open an image as a JPEG, modify it, and resave it, you eliminate pixels. Because the image is further compressed each time, the image quality will grow worse and worse each time you resave—and that's not at all what you want to see happen to your family photos!

Saving your edited files in the TIFF format ensures that you won't have to worry about compression degrading their quality. Photo by Erik Wyand.

Regardless of which image-editing software you elect to use, the main rule of thumb is to save your images in a lossless file format. One of the most commonly used formats is TIFF. Because this format does not compress the image, if you save the image as a TIFF file, then you get exactly what you saved when you open it again. The downside to working with TIFF files is that, since they are uncompressed, they take up more space on your hard drive. Edited TIFF files can also be stored on CDs or DVDs, of course—just like your other images—so this shouldn't present a problem as long as you are careful to regularly back up your files and remove unneeded ones from your hard drive.

FILE FORMAT TIP

Some programs, by default, will automatically save your image in the format in which it was imported. Again, it's important to back up your files on a CD or DVD. That way, you can always go back to the original image file if needed.

35. E-MAIL AND WEBSITES

■ E-MAIL ATTACHMENTS

One of the quickest and most popular way to share photos is as e-mail attachments. Simply write your message, attach the file (consult your web-browser's help files if you're not sure how to do this) and address it to as many people as you like. If you plan to e-mail a photo, save a copy of the image at 72 dpi and in the JPEG format. This will create a smaller file to attach, making it much quicker for the recipient(s) to download and view your photo.

■ WEBSITES

Creating a family website is a unique way to stay in touch with friends and relatives. These can be designed to share baby, wedding, graduation memories, updates, or just as a family history archive.

Some sites, like www.familyplanit.com and www.myfamily.com allow you to quickly build your own website using templates. Creating and posting photos on your personal site takes only a few minutes and requires no programming experience. Depending on the site, you may also be able to make family trees, post family news, send e-mail, and chat, too!

If the thought of designing your own site leaves you feeling weak in the knees, visit www .celebrateourroots.com. Their personnel will design a site for you. Visit the site to view samples of a variety of pages.

If you want to build a site from the ground up, you can either learn HTML or use software like Microsoft FrontPage or Adobe InDesign.

Did your daughter win an important award at school or move up in marching band? Are you planning a family reunion? With a personalized family website, you can share photos and family news with friends and family nationwide—even around the world!

36. LAB AND ONLINE PRINTING

Traditional photo labs—whether a small counter in a department store or drug store or a freestanding lab/camera store that caters to photographers—are another option for printing your images. Like online printing labs, these labs produce prints that will stand the test of time and are perfect for displays, photo albums, or scrapbooks.

■ PHOTO KIOSKS

Many supermarkets, drugstores, department stores, and photo specialty stores have photo kiosks that allow you to download your images, make basic image corrections, and create prints. These prints are made using a dye-sublimation printer, meaning that you'll obtain a better-quality image than you will when using your inkjet model (see lesson 37). The prints will probably last longer, too—however, there's no real consensus as to exactly how long, though some sources say it may take ten to sixty years before the image starts to visually degrade. Printing the images takes just a matter of minutes.

■ ONLINE PHOTO LABS

Did you know that you can order prints (very economically) on the web? Visit websites like www.hpphoto.com, www.snapfish.com, www.shutterfly.com, www.photosmart.com, and www.ofoto.com not only to get prints, but to

TIPS FOR LAB PRINTING

1. Have a few prints made to determine the quality before ordering a lot. It's also important to note that the image quality will depend on the person operating the machine and will vary from order to order.

2. All prints deteriorate over time, some faster than others. Lab printing will likely ensure the longest lifespan of your photos. It may take ten to sixty years before your lab prints will begin to fade and the colors will start to shift. While professional labs use the same papers and equipment to make prints from digitals that are used for film processing, some inks and papers are more durable than others. For the best results, store your images out of direct sunlight in a cool, dry place and select acid-free mats and UV-coated glass when framing your images.

Print longevity is an important issue for digital photographers. If you just want a cute snapshot to stick on the fridge for a few weeks, any type of printing will probably do. If you're creating a baby book that want to last for years—hopefully decades—you'll want to seek more archival printing methods. Image above by Virginia Green.

place orders for special gifts that feature your favorite photos (see lesson 39). These prints are more archival than prints made at home and may even last longer than prints made at a photo kiosk.

37. HOME PRINTING

Before you can determine what the best method is for you, you need to evaluate what you are going to be using your images for. Do you just want to make notecards to send to friends? Will you make prints to hang on the fridge? Do you want to create archival prints for a family album?

While different printers have different functions and purposes, Canon, Epson, Hewlett Packard, Kodak, and Sony all manufacture printers that are worth considering. There are two basic types that are commonly used by consumers: inkjet and dye-sublimation.

■ INKJET PRINTERS

Inkjet printers are a great option when the longevity of the print is not an issue. If you want to design a newsletter or bulletin, make greeting cards, or

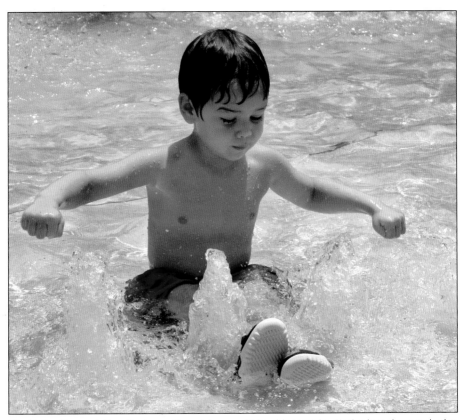

The higher the resolution, the larger the prints you will be able to make. Notice how sharp and crisp the water appears in this image. It was captured with the 6.3MP Canon Digital Rebel, which is currently one of the best consumer-grade digital cameras on the market. Image by Amy Littrell.

TIPS FOR HOME PRINTING

1. When selecting a printer, keep in mind that some lower-cost models rely on tiny ink cartridges that will need to be frequently replaced. While such a printer may initially seem like a bargain, replacing these cartridges may cost you more than paying for a higher-quality printer!

2. After printing, do not stack your images; allowing 24 hours' drying time will ensure that your prints won't stick together.

just briefly display a funny photo on your refrigerator, such a printer will suit your needs. You can find a wide variety of photo papers and other stationary for use with these printers at your local camera store or office supply store. Beware: If these images get wet, the ink will bleed.

Even with inkjet printers, several variables can effect the longevity of prints. One of these variables is the type of ink used. Prints made with dye-based or color-fast inks are best stored under glass, because it protects them from being affected by natural gasses and environmental exposure. These prints can have resistance to fading for anywhere from up to six months to twenty years depending on how they are cared for and stored. If stored improperly, they can also fade within a matter of weeks! When selecting this style of printer to print your image, ask yourself, "Am I going to frame this image under glass?" "Will I be upset if this image fades in the next six months or ten years, or will I be able to reprint the image if needed?"

Many new printers offer pigment-based inks that promise to be more resistant to fading and hold the image color for up to fifty years. However, these are still experimental, so there is no way to validate this claim.

■ DYE-SUBLIMATION PRINTERS

You can also purchase a consumer-grade dye-sub printer. These are more expensive (both to purchase and operate) than inkjet models, but they produce better-quality, more archival prints. Of course, much depends on the paper and inks selected for the job. The final print is covered with a coating to prevent fading, making your image last longer.

38. DISPLAYING YOUR IMAGES

■ FRAMING PRINTS

Today, there are a wide range of frames on the market, ranging from fun and fanciful to handsome and classic. You can shop for frames at a wide range of places and can have custom framing done at a specialty shop or at most larger craft stores.

Matboard lends a nice finishing touch to framed prints. This comes in many colors and textures, from a canvas look to a sueded one. When purchasing preassem-

Nicely framed photographs are a wonderful addition to your home. They also make great gifts for friends and family.

Adobe Photoshop Album lets you create web albums using predesigned templates.

Adobe Photoshop Elements also lets you create digital albums. In this one, you click on the small image at the bottom of the page (this is called the thumbnail) to see a larger version of the image appear on the "stage."

bled frames, ensure that the one you've selected will accommodate matboard. Not all frames do.

For the best results, choose UV-coated glass and acid-free matboard. These products will help ensure the archival quality of your prints.

■ DIGITAL ALBUMS

One of the most popular types of digital-imaging software allows you to create virtual "albums" to be viewed on screen or printed out. Some even let you create a DVD of your album that will play on your home theater system. Adobe Photoshop Album (www.adobe.com) is popular, as is Flip Album (www.flipalbum.com).

39. PHOTO GIFTS

Put your new image to great use with some creative and fun projects. Websites like www.hpphoto.com, www.photosmart.com, and www.ofoto.com are not just helpful resources when it comes to creating traditional printed images but also can help you create fun projects like stationery, scrapbooks, CD covers, lunch bags, greeting cards, lockets, and many other exciting items.

Imagine surprising your son or daughter with customized trading cards or a personalized poster! You can even print your own car decals, which is sure to make your kid feel extra special when you pick him or her up in the carpool lane!

Office supply and printing stores can also help you create fun photo gifts like calendars, mugs, t-shirts, mouse pads, and laminated place mats and bookmarks. Be sure to allow adequate time for production close to the holidays and receive a copyright release for any professionally photographed image.

These are just a few examples of the fun photo gifts you can create.

40. CONTESTS

If you have captured an image you think is adorable, unique, classy, or even funny, consider entering a photography contest. Many publications, stock photo agencies, and other photo-related companies encourage submissions from amateur photographers. You will be surprised at the amount of accolades and prizes that may be waiting for you! If this is something that appeals to you, follow these steps for getting started:

1. Do an Internet search to view a listing of some basic opportunities. Check out these links to get started:

 www.child.com/covercontest/entry_form.jsp
 www.americanbabycontest.com
 www.babyzone.com/contest/photocontest.asp
 www.kolo.com

Do you have an image that is cute enough to make you smile? Consider entering it in a photo contest—you never know what you could win!

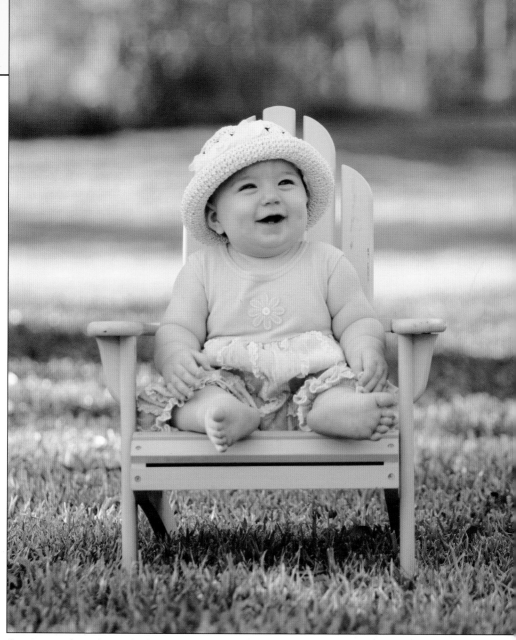
Great expressions often make for memorable images.

Donna Poehner and Erin Nevius's *Photographers Market: Places to Sell Your Photographs* is another great resource.

2. Organize the image files you think you may want to submit in a separate folder, then have someone review your images and tell you which photos they think you should submit.

3. Review the submission guidelines and send off your image(s)!

41. CALLING IN THE PROS, PART 1

■ THE BENEFITS OF HIRING A PRO

While you may be able to produce prize-winning images with some photo experience under your belt, it is important to realize that there are occasions when you should rely on the skills of a professional photographer.

Sheri Ebert, of Ebert Images, explains, "Hiring an experienced professional photographer is important for the same reason as it was when film cameras were prominent in the industry. A professional photographer is responsible for making split-second judgment calls on shutter speed and aperture in varying lighting situations. Typically, professional photographers know more about lighting, posing to flatter the subjects, and working with people to document their memories."

■ RESEARCHING YOUR OPTIONS

There are many resources available for finding a good photographer. For one, you can search professional photographers' association websites such as www.ppa.com or www.wppinow.com to find a list of professionals in your area. You can also review the work in local magazines and peruse local business displays. Asking your friends for referrals may also be helpful. It's important to seek out a photographer whose work you truly enjoy. By developing a long-term rela-

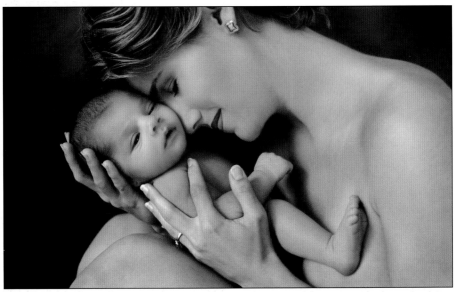

If you would feel more comfortable being photographed by a female, ask if a female photographer is available for those intimate sessions. Photo by Sheri Ebert.

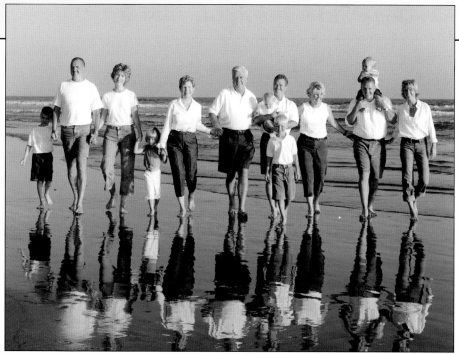

Consider hiring a professional to conduct your family portrait so everyone can be included. Ask about recommended clothing for the portrait to ensure the best possible results! And remember: the better your relationship with your photographer, the better the images will be. Top photo by Kay Eskridge. Left photo by Jeff Hawkins.

tionship with your photographer, you are more likely to be comfortable during your session and to appear more natural in your images.

■ FINDING YOUR MATCH

Though you can book a photographer over the phone after viewing his or her work online, it's best to schedule a face-to-face consultation. During this time, you can learn about pricing, procedures, and more. You want to be sure that the photographer is someone you can trust and will feel comfortable working with. Photographer Jeff Hawkins of Jeff Hawkins Photography, says "If the personalities do not mesh well, it will definitely show in the outcome of the images."

42. CALLING IN THE PROS, PART 2

■ ANALYZING YOUR BUDGET

You'll want to ensure that your photographer's prices are well suited to your budget. Keep in mind, just because your family lowered expenses when converting to digital technology doesn't mean the professional photography studio's expenses were lowered with their transition. In fact, any savings are now likely spent on additional labor, liability insurance, and operational expenses. When purchasing professional photographs, you are paying for the artwork and the artist's creation. With digital technology, your photographer can now enhance your images like never before. Of course, this takes time, and time is money.

Traditional portraiture is typically conducted in the studio, using studio lighting and a backdrop—but it can be created anywhere. Photo by Jamie Hayes.

Many photographers create "narrative portraits." These storytelling portraits document your child in their element and the sessions are often conducted on location. Photo by Mary Fisk-Taylor.

Many parents' first impulse is to call a studio and request package prices. While a price range can be helpful, there are many things that go into pricing, and these may not be apparent in the initial price quote. As a result, you may end up spending more than you intended. Don't base your decision solely on cost or on the number of pictures you will be getting, or your images may not look much different than those you can create on your own!

CLOSING THOUGHTS

Don't put off until tomorrow what you can do today. Share your precious moments and memories with your family and friends. Take advantage of the opportunities that new technologies offer, and share the results with the ones you love. Create a family website and make unique gifts that showcase your best images. Capture what you can on your own, but acknowledge the benefits of hiring a professional, too. Begin the journey to creating your visual history, and pass those memories on for the generations that follow. Finally, when shooting your images, follow your heart. Keep in mind, the images you capture today will be the treasured mementos of tomorrow!

ABOUT THE AUTHOR

Kathleen Hawkins is an advisor and consultant to photographers throughout the country. She is the author of *Marketing and Selling Techniques for Digital Portrait Photography* (2005), *Digital Photography for Children and Family Portraiture* (2004), and *The Bride's Guide to Wedding Photography* (2003), all from Amherst Media. She and her husband Jeff operate an international award-winning wedding and portrait photography studio in Orlando, FL. Industry sponsored, they are both very active on the photography lecture circuit and take pride in their impact in the industry. They conduct private consultations and lead workshops at photography conventions worldwide, educating photographers on the products and services that create a successful business.

ACKNOWLEDGMENTS AND CONTRIBUTORS

■ ACKNOWLEDGMENTS

Special thanks to Jonathon Snyder from Circuit City for helping me with all of my consumer-grade digital camera questions, Loryn Sabelli for being there to help me with whatever I needed to complete this task, and Laura Hawkins, Elisa Delgardo, and Kim and Ryan Wakefield for giving it your best effort to get me images, even if it didn't work out. Mom, as always, you were there to help when I needed you! Thanks for gathering up the images so quickly.

■ AMATEUR PHOTOGRAPHERS

Thanks to all of our amateur/hobby photographers for their contributions. Without your help, we would not have been able to complete this project. Your submissions were terrific!

Angi Aveyard	Lynda Farquhar	Stephanie Moore
Bonnie Califano	Laura Green	Mary Ellen Nelson
Elizabeth Cook	Virginia Green	Tim Paris
Tom Chuparkoff	Lydia Horan	Kim Wakefield
Elisa Delgardio	Virginia Infante	Loretta Wall
Kyle Ebner	Amy Littrell	Erik Wyand

■ PROFESSIONAL PHOTOGRAPHERS

A special thank you goes out to our experts, Sheri Ebert, Kay Eskridge, Mary Fisk-Taylor, Jeff Hawkins, and Jamie Hayes for their contributions and advice. Their knowledge in the industry and willingness to take time out of their busy schedules is greatly appreciated.

Sheri Ebert
Sheri Ebert Photography
Jacksonville, FL
904-230-8137
www.ebertimages.com

Jeff Hawkins
Jeff Hawkins Photography
Longwood, FL
407-834-8023
www.jeffhawkins.com

Kay Eskridge
Images by Kay & Co.
Phoenix, AZ
602-393-9333
www.imagesbykay.com

Jamie Hayes and Mary Fisk-Taylor
Hayes & Fisk—The Art of Photography
Richmond, VA
804-740-9307
www.hayesandfisk.com

RESOURCES

■ EDUCATIONAL WEBSITES

www.dpreview.com

www.imaging-resource.com

www.pricewatch.com

www.peimag.com

www.pcworld.com

www.consumerreports.org

www.wppinow.com

www.ppa.com

■ IMAGE EDITING AND SOFTWARE WEBSITES

www.adobe.com

www.apple.com

www.acdsystems.com

www.basepath.com/Albumatic

www.hpphoto.com

www.snapfish.com

www.photosmart.com

www.ofoto.com

INDEX

THE BRIDE'S GUIDE TO WEDDING PHOTOGRAPHY

Kathleen Hawkins

Learn how to get the wedding photography of your dreams with tips from the pros. Perfect for brides. $14.95 list, 9x6, 112p, 115 color photos, index, order no. 1755.

BEGINNER'S GUIDE TO
ADOBE® PHOTOSHOP® ELEMENTS®

Michelle Perkins

This easy-to-follow book is the perfect introduction to one of the most popular image-editing programs on the market. Short, two-page lessons make it quick and easy to improve virtually every aspect of your images. You'll learn to: correct color and exposure; add beautiful artistic effects; remove common distractions like red-eye and blemishes; combine images for creative effects; and much more. $29.95 list, 8½x11, 128p, 300 color images, index, order no. 1790.

PROFESSIONAL SECRETS FOR
PHOTOGRAPHING CHILDREN

2nd Ed.

Douglas Allen Box

Covers every aspect of photographing children, from preparing them for the shoot, to selecting the right clothes to capture a child's personality, and shooting storybook themes. $29.95 list, 8½x11, 128p, 80 color photos, index, order no. 1635.

THE PRACTICAL GUIDE TO DIGITAL IMAGING

Michelle Perkins

This book takes the mystery (and intimidation!) out of digital imaging. Short, simple lessons make it easy to master all the terms and techniques. Includes: making smart choices when selecting a digital camera; techniques for shooting digital photographs; step-by-step instructions for refining your images; and creative ideas for outputting your digital photos. Techniques are also included for digitizing film images, refining (or restoring) them, and making great prints. $29.95 list, 8½x11, 128p, 150 color images, index, order no. 1799.

STEP-BY-STEP DIGITAL PHOTOGRAPHY, 2nd Ed.

Jack and Sue Drafahl

Avoiding the complexity and jargon of most manuals, this book will quickly get you started using your digital camera to create memorable photos. $14.95 list, 9x6, 112p, 185 color photos, index, order no. 1763.

PROFESSIONAL SECRETS OF
NATURAL LIGHT PORTRAIT PHOTOGRAPHY
Douglas Allen Box

Leanr how you can use natural light to create hassle-free portraiture of any subject—children, families, couples, and more. This book is beautifully illustrated and features detailed instructions on selecting equipment, choosing and modifying lighting, and flawless posing techniques. $29.95 list, 8½x11, 128p, 80 color photos, order no. 1706.

HOW TO PHOTOGRAPH YOUR BABY'S FIRST YEAR
Laurie White Hayball and David Hayball

Don't miss a moment of your baby's first year. With the easy photo recipes in this book, new moms and dads will be ready to capture the many changes and milestones in their child's development—from baby's first steps, to holiday firsts, and even his or her first birthday party. Filled with quick tips for busy parents, this book is a perfect baby shower gift. $14.95 list, 6x9, 112p, 70 color photos, order no. 1765.

BEGINNER'S GUIDE TO PHOTOGRAPHIC LIGHTING
Don Marr

Create high-impact photographs of any subject with Marr's simple techniques. From edgy and dynamic to subdued and natural, this book will show you how to get the myriad effects you're after. $29.95 list, 8½x11, 128p, 150 color photos, index, order no. 1785.

SEP '05 SOUTH HILL